T0272876

THE SKETCHBOOK OF A GENTLEMAN

TUSCANY · ROBIN LUCAS

COLLECTIVE SHORTS
by NHP PUBLISHING

To my parents

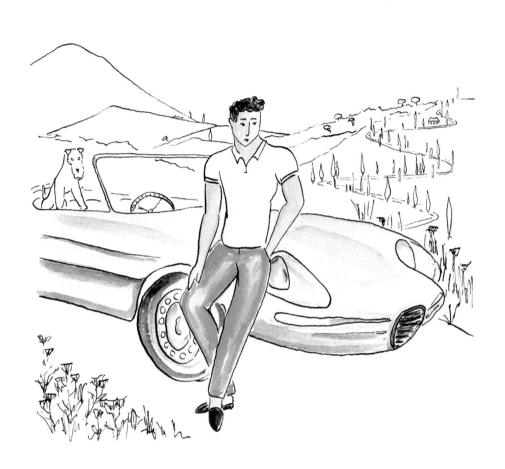

The Sketchbook of a Gentleman – Tuscany

Italy has a long and intimate relationship with art. Some of the greatest artists in history hail from Italy and their work can been seen in every part of Italian life, from its majestic churches to virtuoso architecture. The hill towns of the Val d'Orcia, and the world famous cities of Florence and Siena, are the very epitome of this heady cultural mix.

Famously, food and family are also integral to Italian life, with recipes and cultural heritage being passed down through generations. Every region of Italy has a deep pride in its food and wine; Tuscany is no exception. Sometimes even the most familiar road can yield hidden gems; private houses, gardens, and Osterias tucked away in ancient villages.

This book is the second instalment of Edward's illustrated travels, where, ever the gentleman, he journeys through the heart of Tuscany enjoying all aspects of that privileged region.

Monday

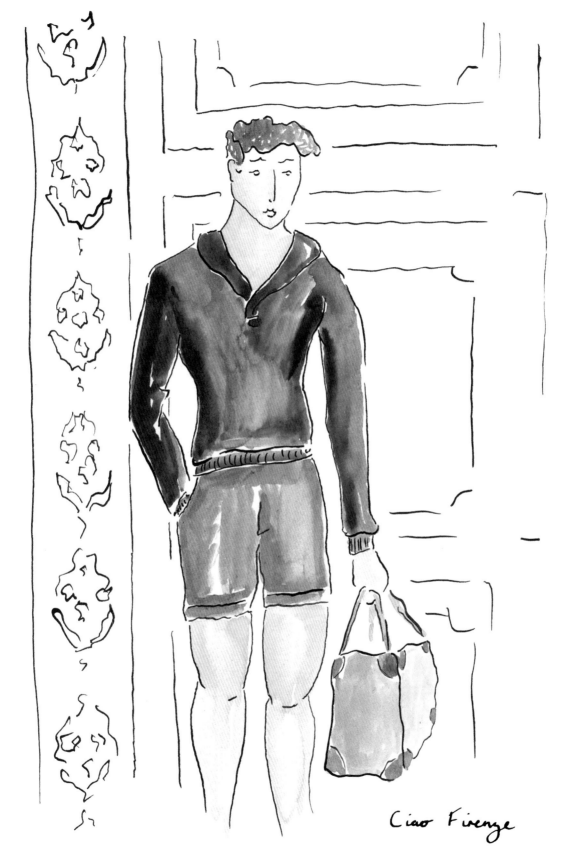

Ciao Firenze

One can escape London,

but apparently not the crowds

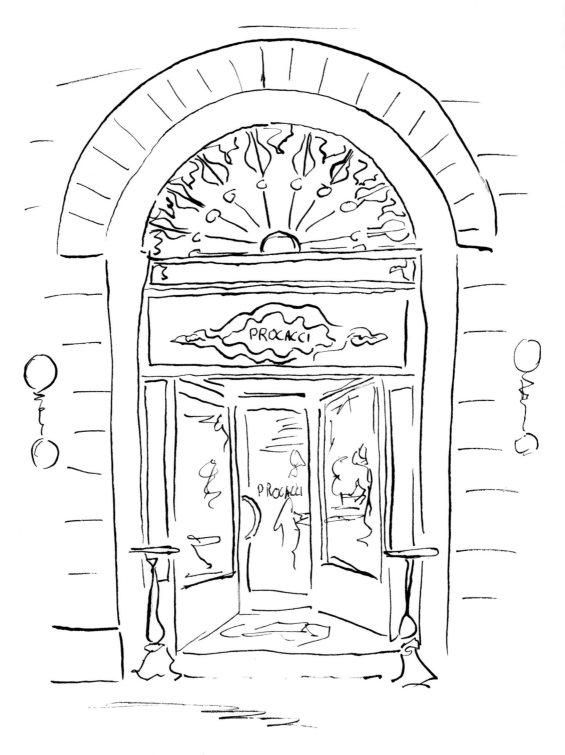

Via Tornabuoni 64/r 50123

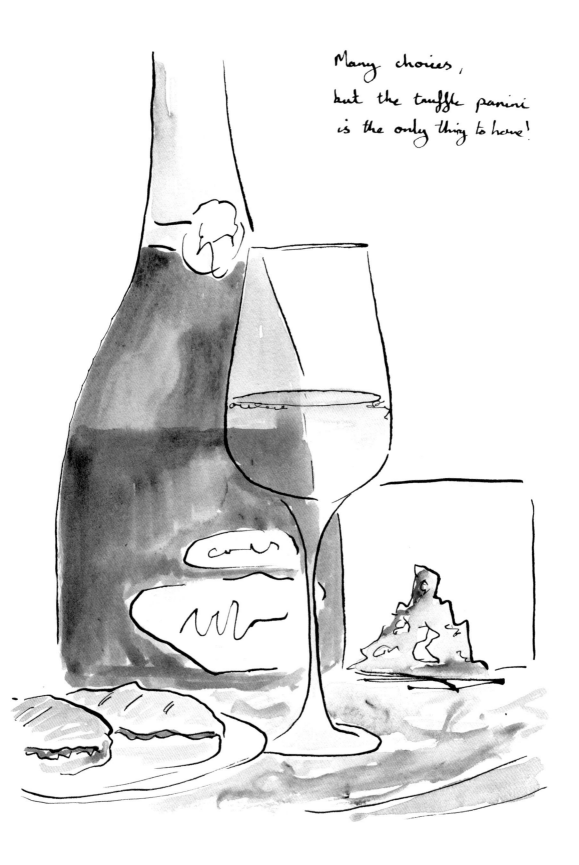

Many choices,
but the truffle panini
is the only thing to have!

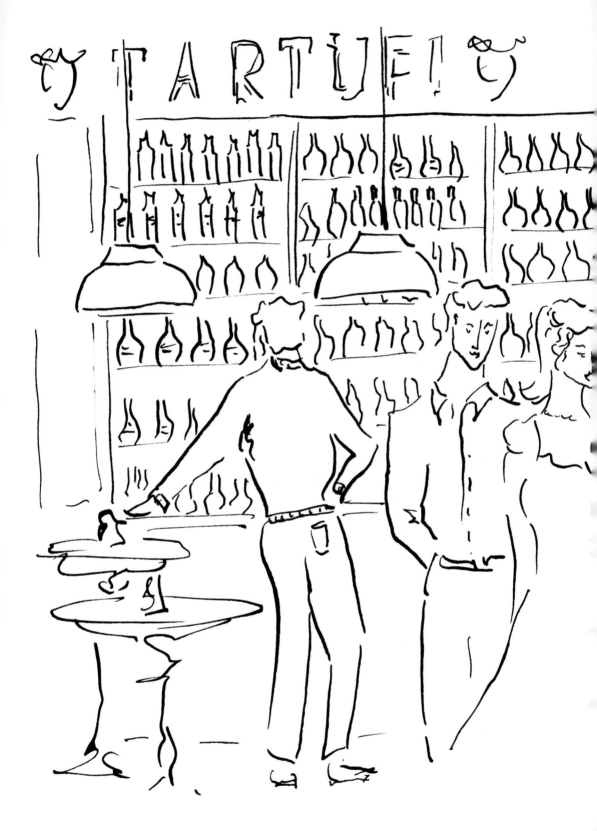

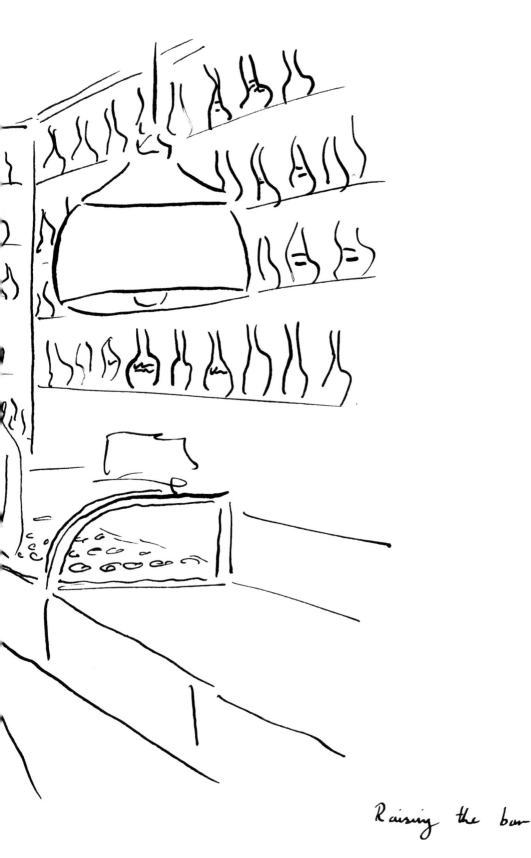

Raising the bar

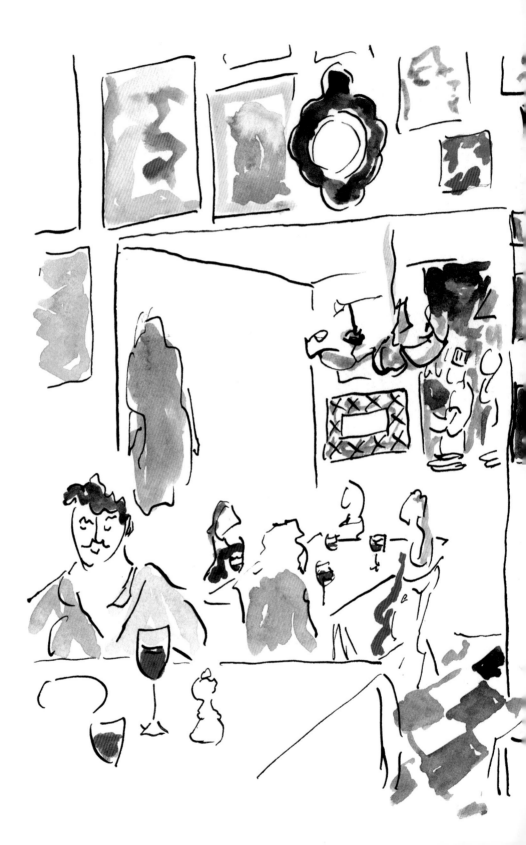

The Primi Sali
- Tratoria Cammillo

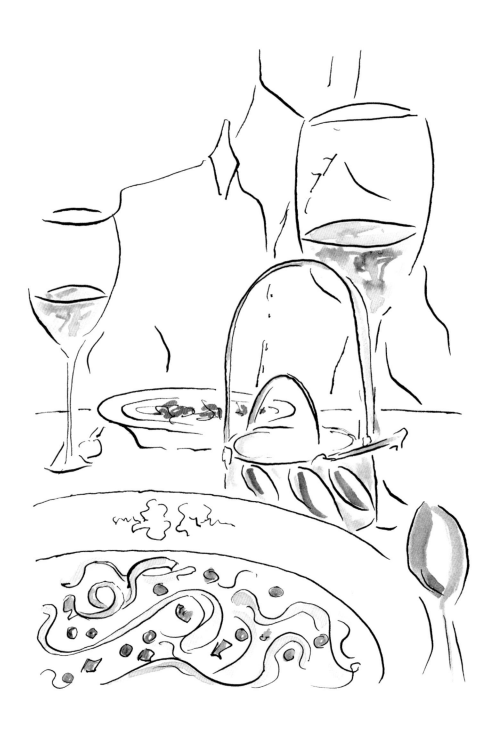

Tagliolini con prosciutto e piselli

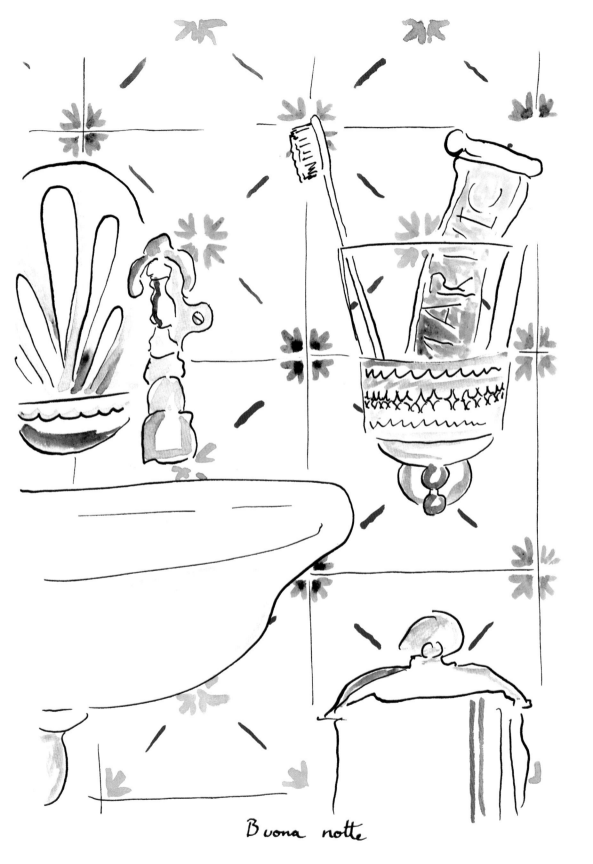

Buona notte

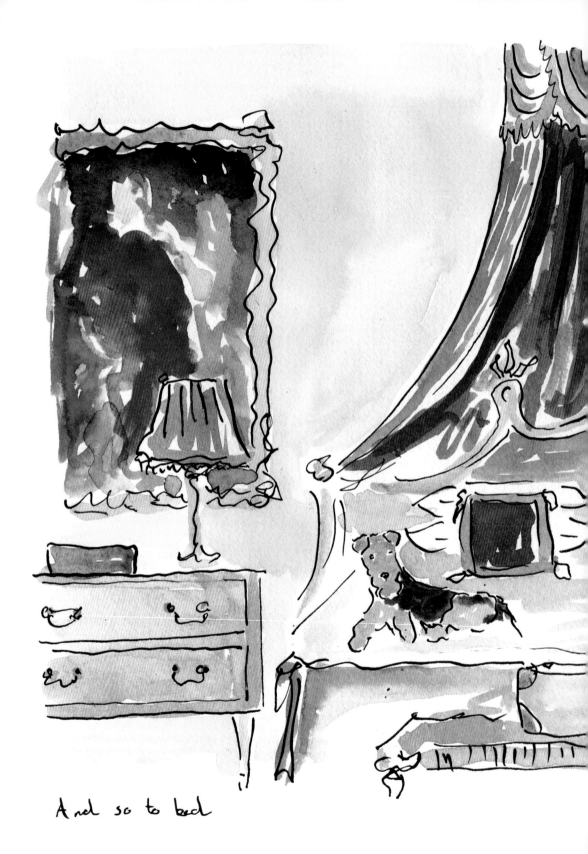

And so to bed

Tuesday

The most important meal of the day

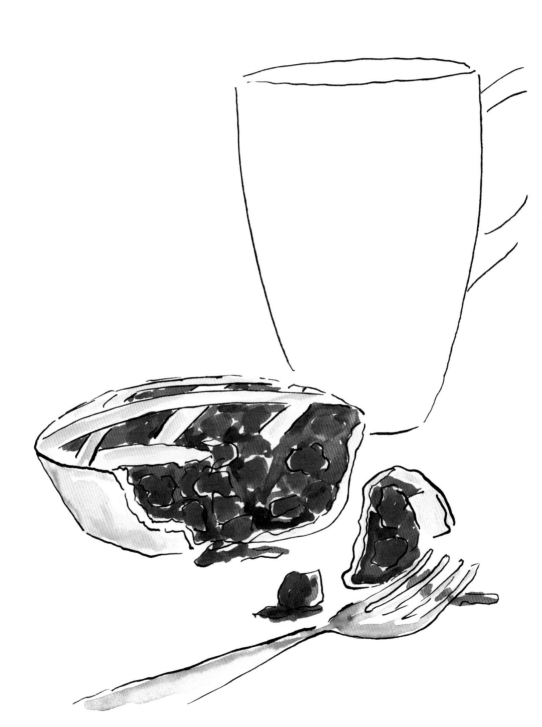

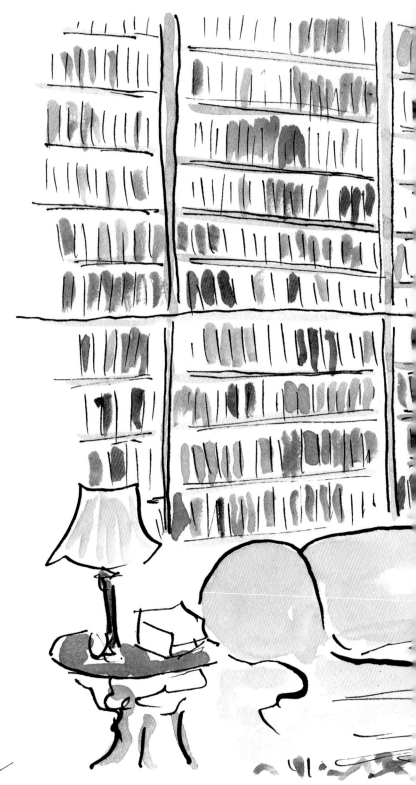

The Harold
Acton Library

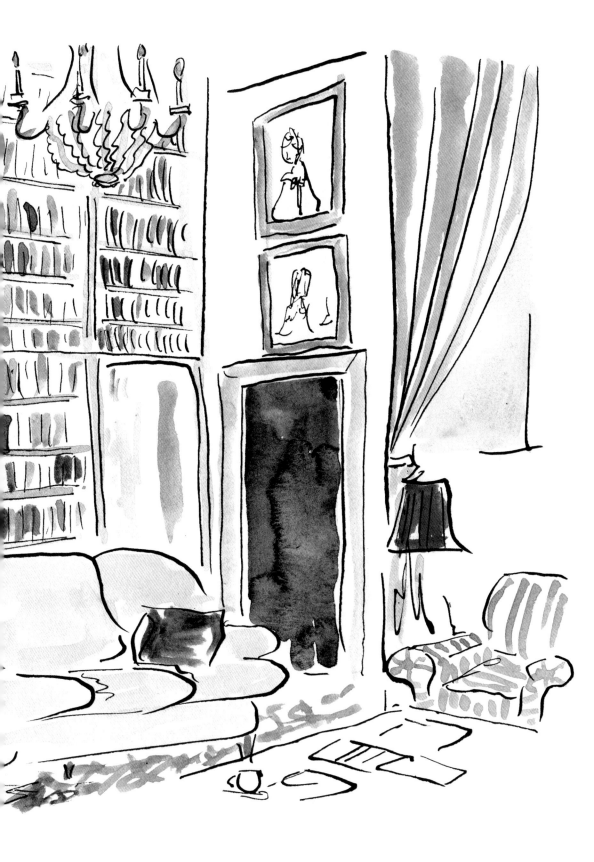

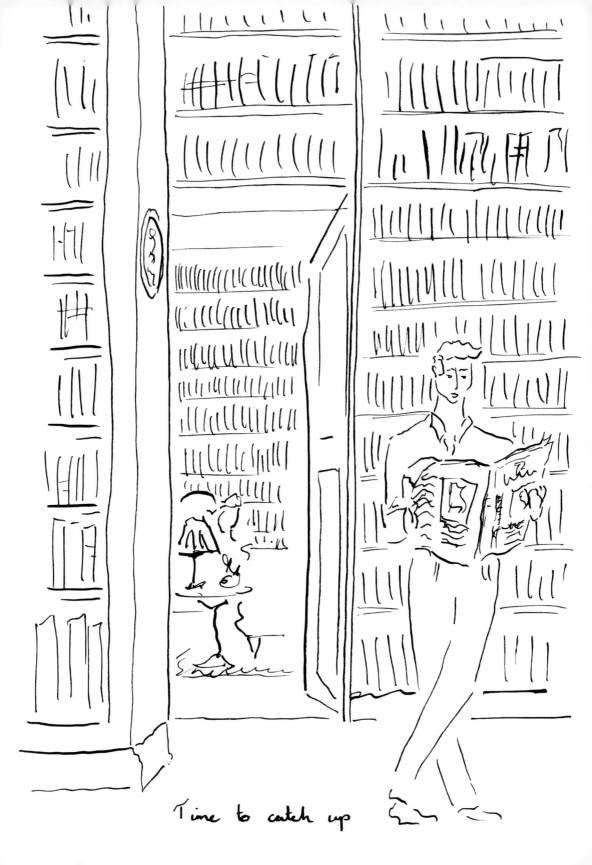

Time to catch up

A light lunch today

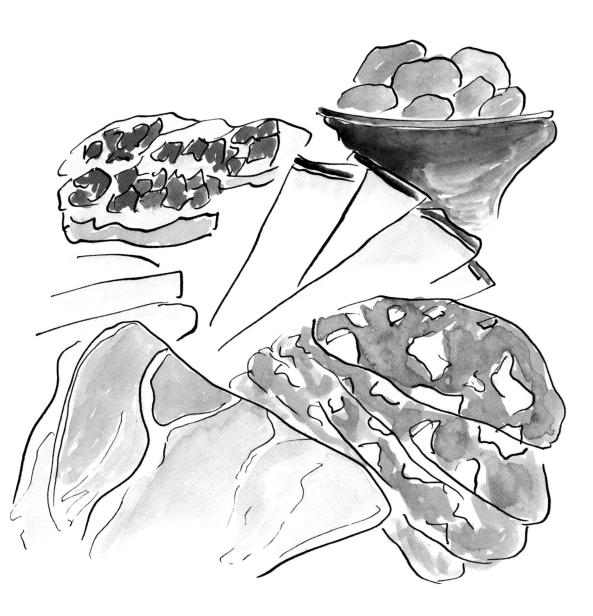

'You will begin to wonder that human daring ever achieved anything so magnificent.' Ruskin

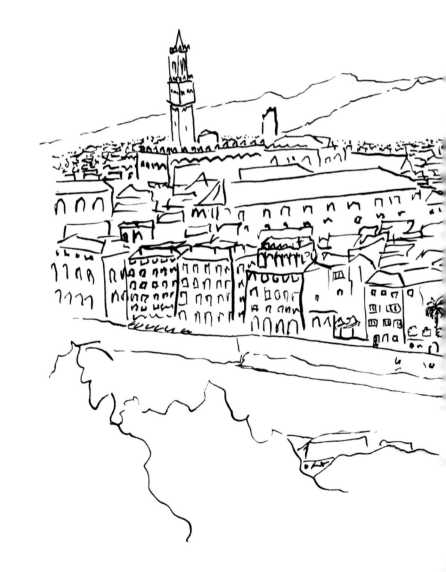

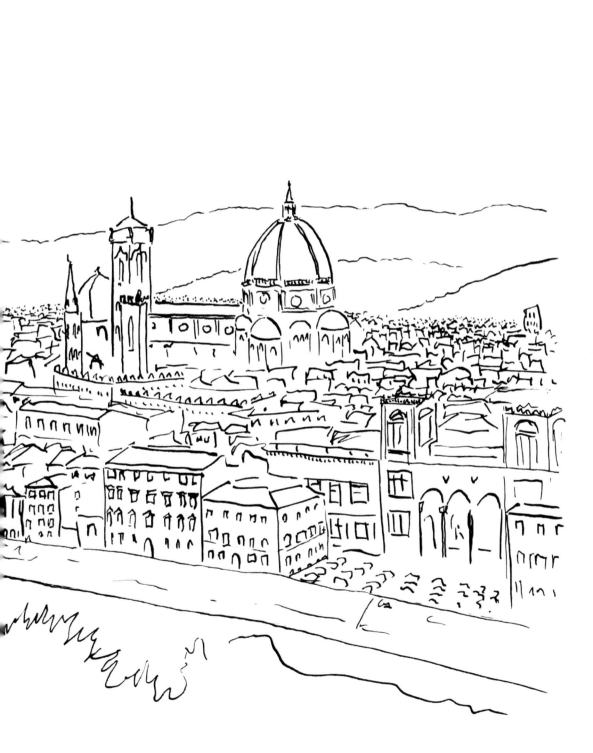

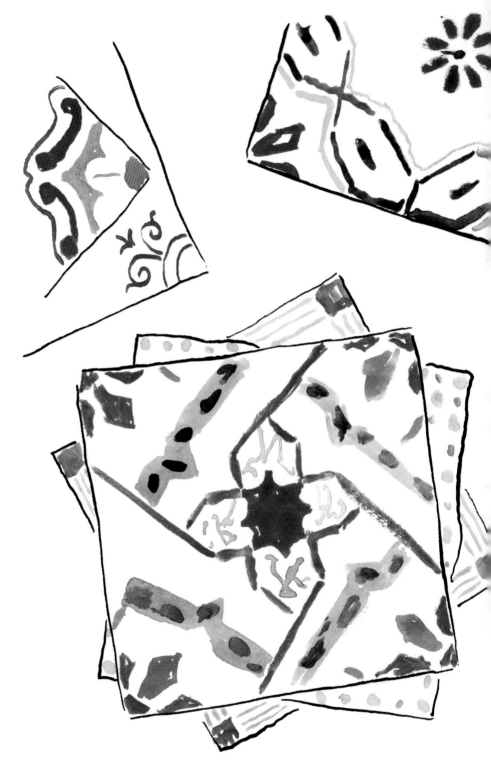

Too heavy for my luggage

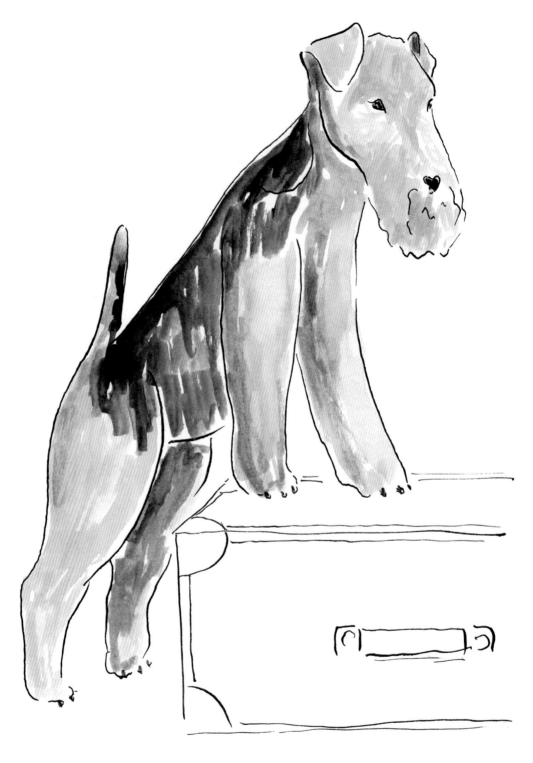

He's a great travel companion

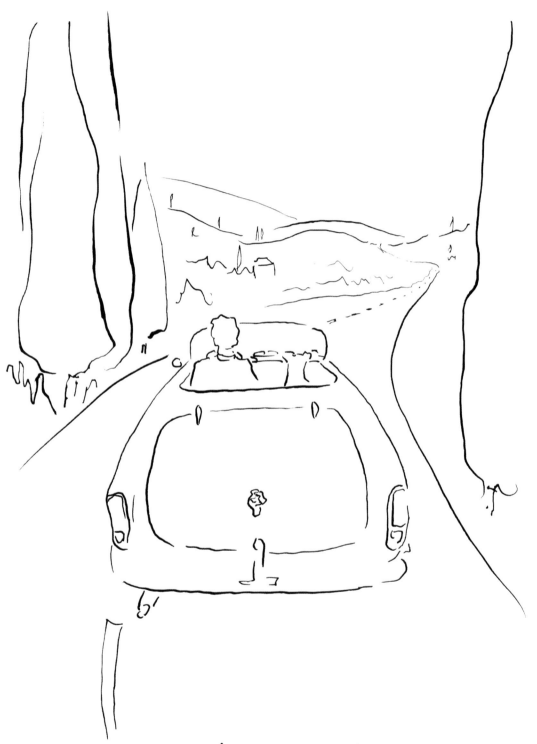

but no so great with maps

Wednesday

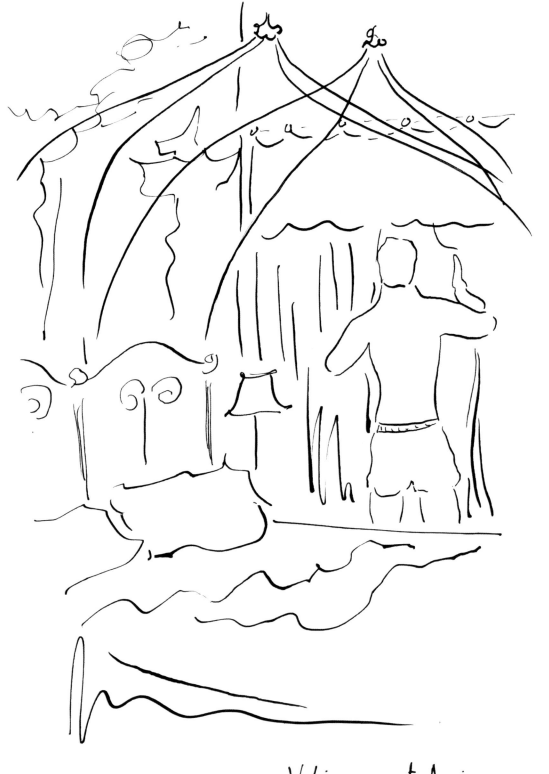

Waking up at Arniano

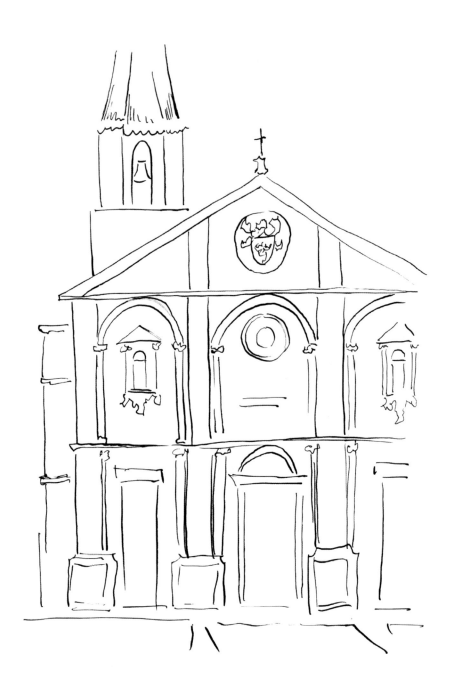

Six centuries later, and still standing ...

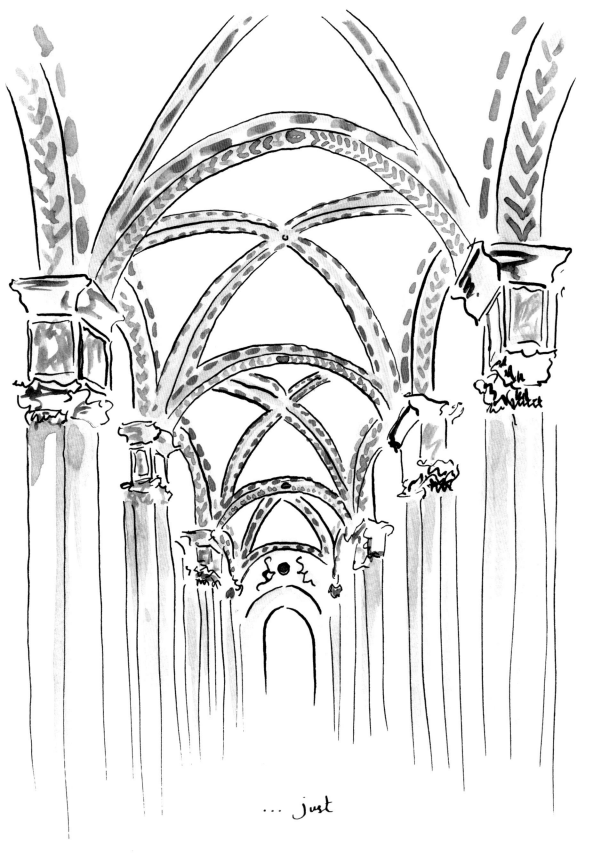

... just

A warm welcome at La Bandita Townhouse

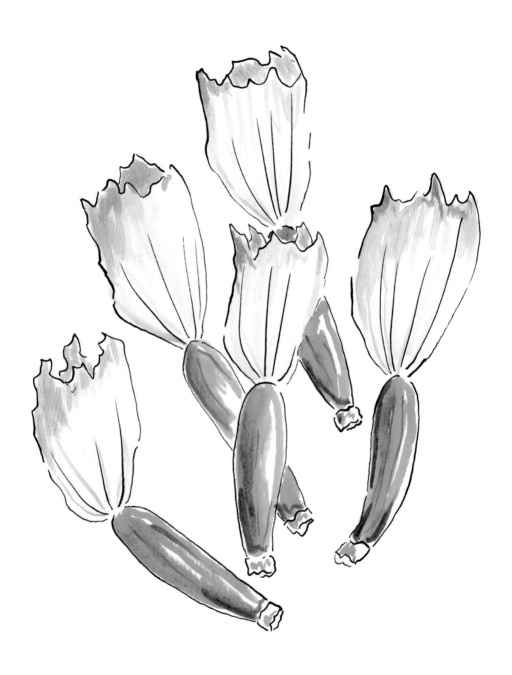

Fiori di zucca

'Images and Shadows' at La Foce

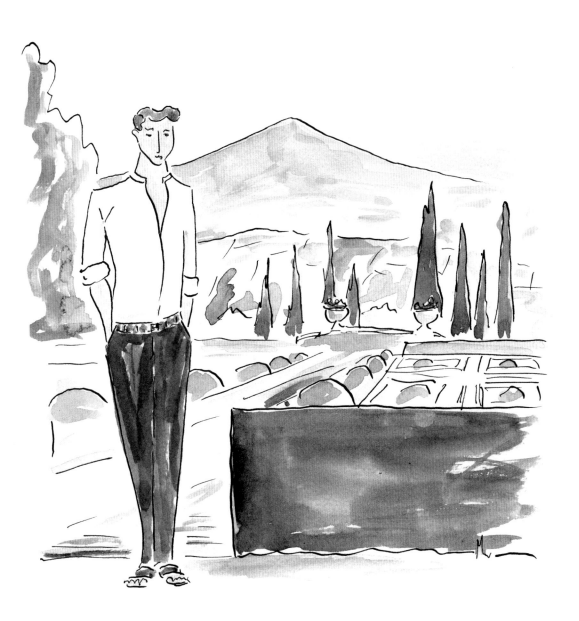

Cecil Pinsent's garden for Iris Origo

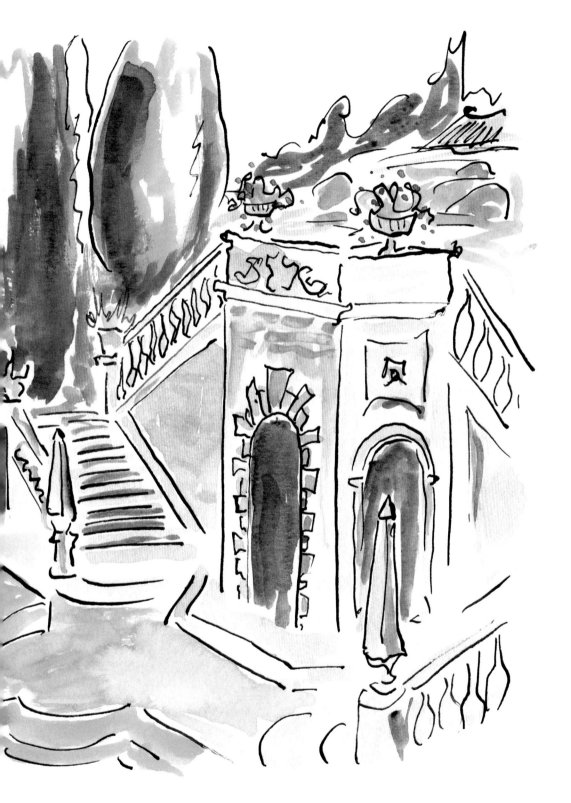

- a true masterpiece

Via del Piano, 1, Monticcihello

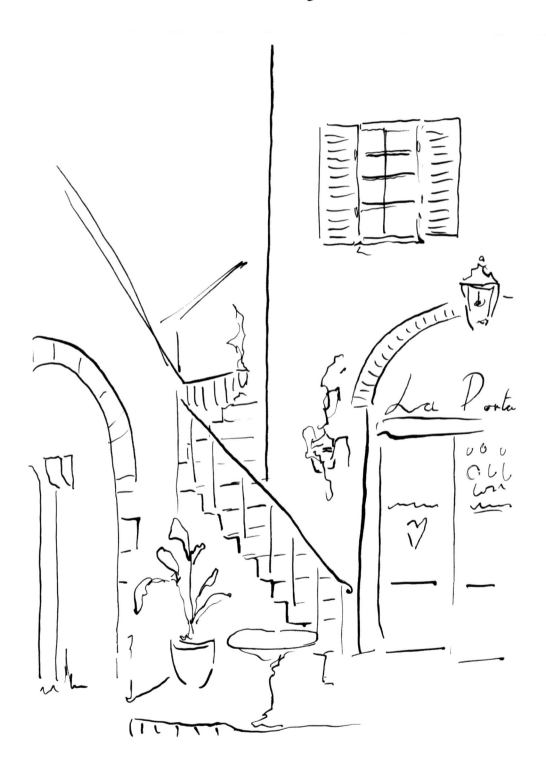

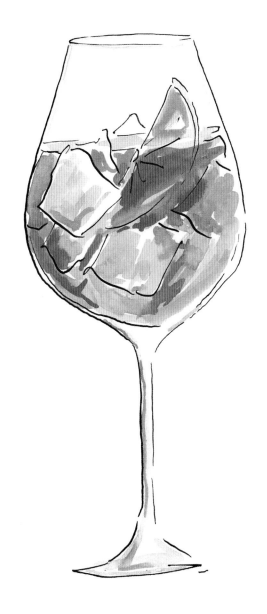

Ice, equal prosecco and Aperol with a dash of
soda and a slice of orange

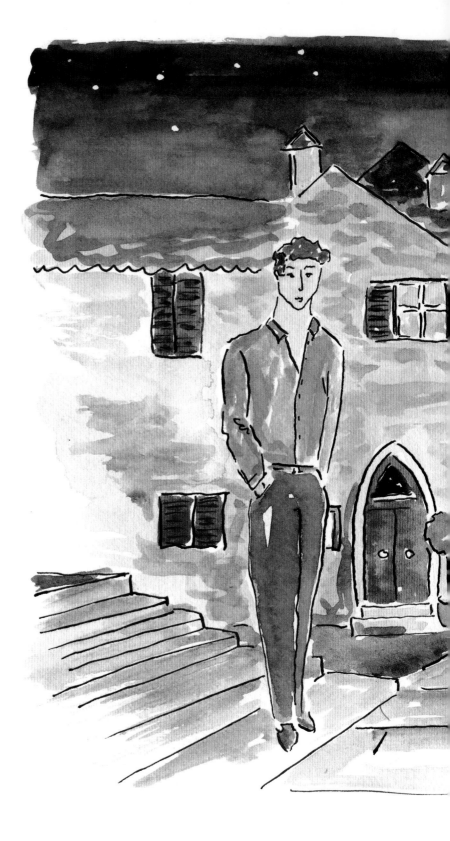

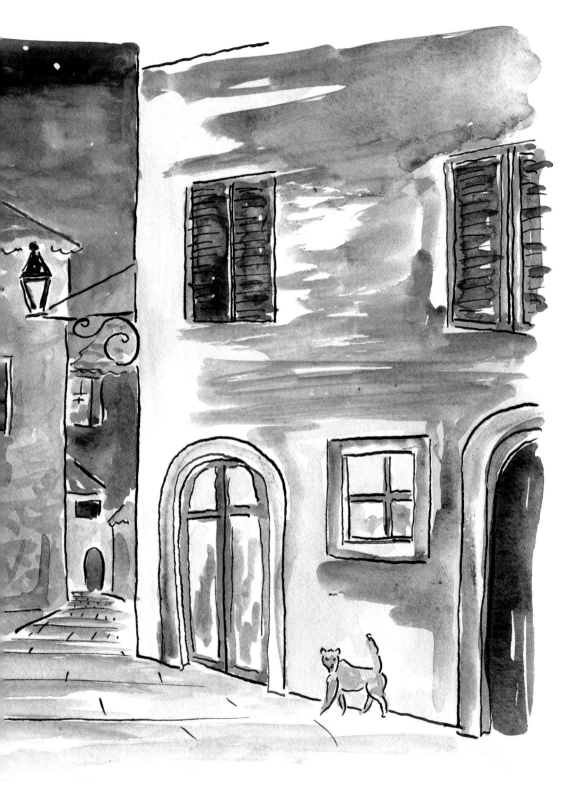

A post dinner saunter

Thursday

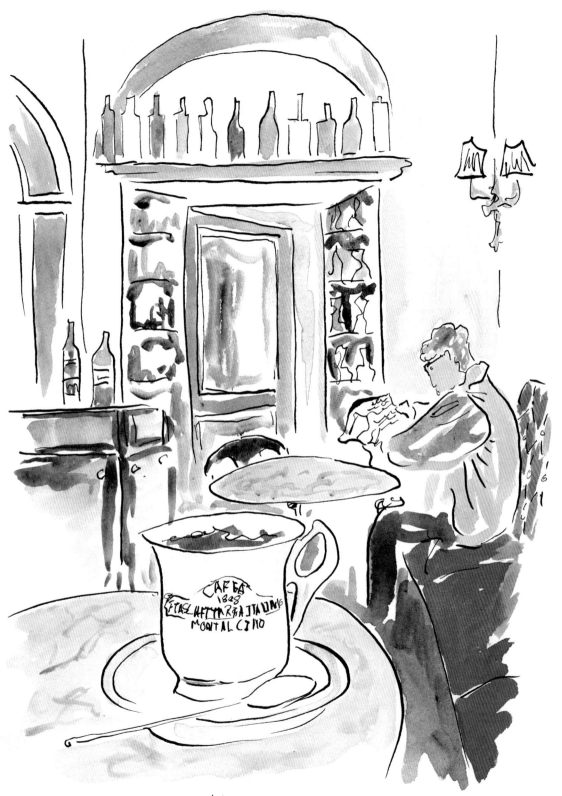

Never trust a café without regulars!

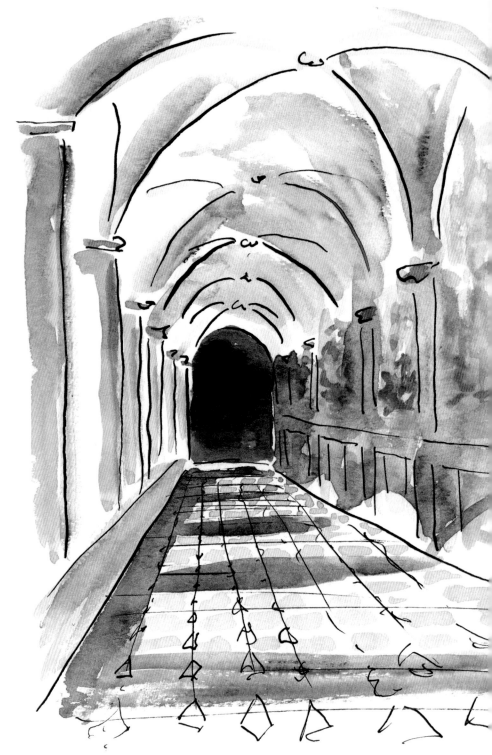

The Sodoma frescos,
Abbazia Monte Oliveto Maggiore

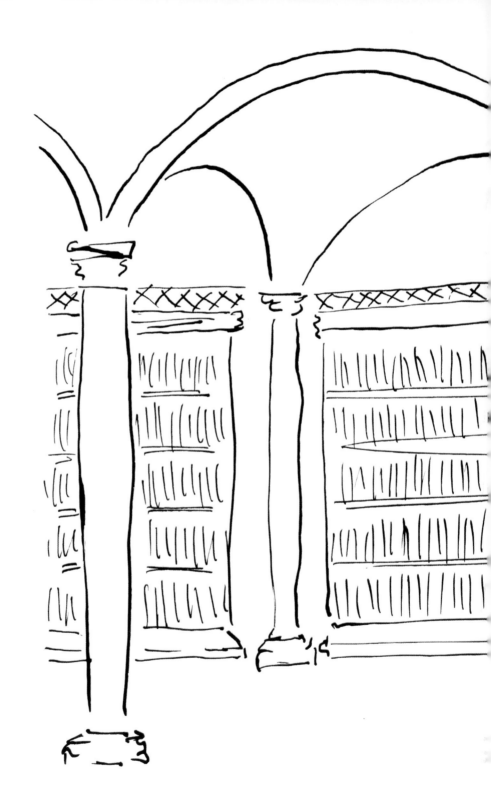

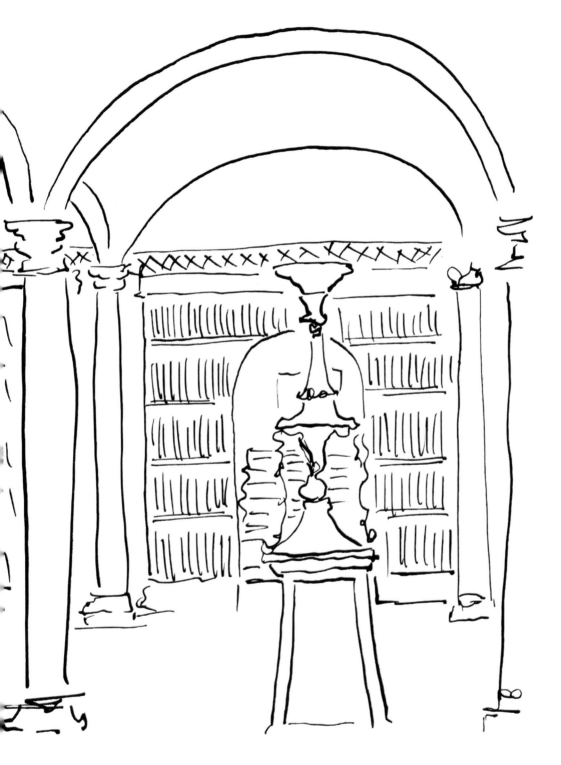

Why not judge a book by it's cover?

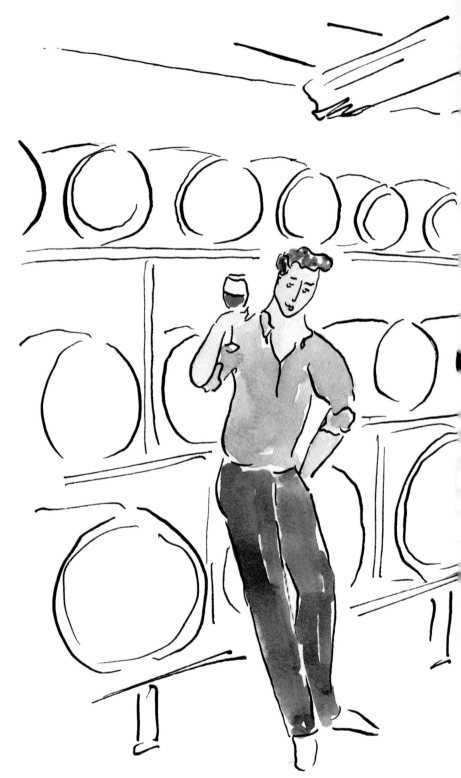

It would be foolish not to!

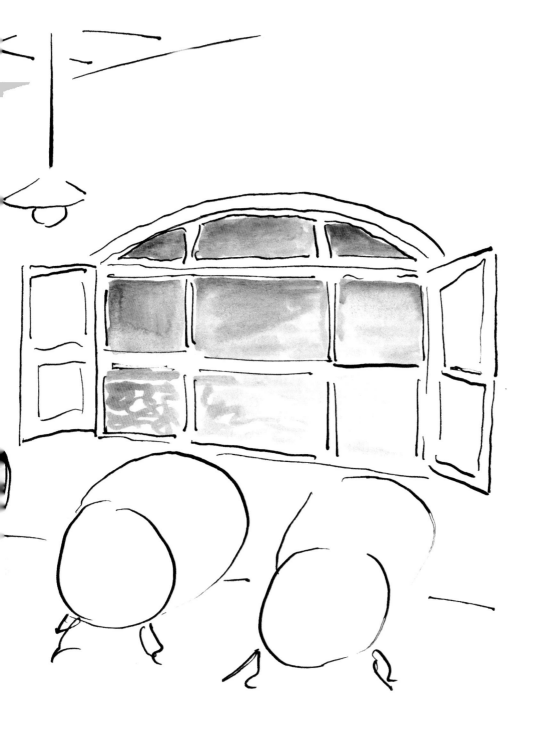

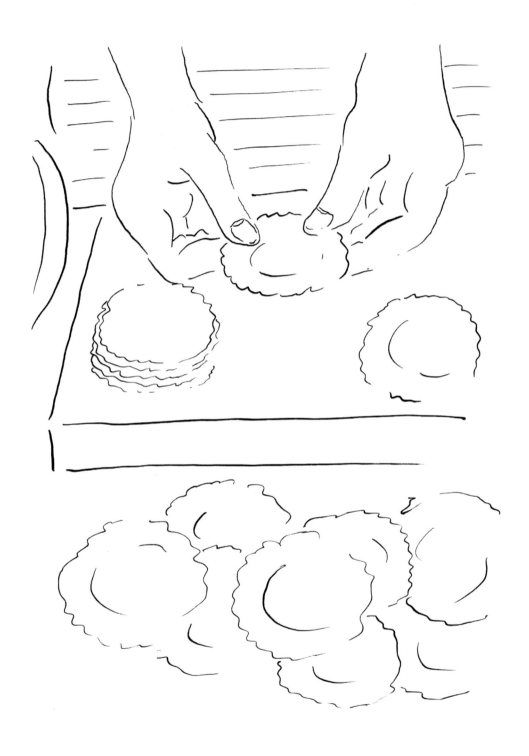

Like Nonna made it

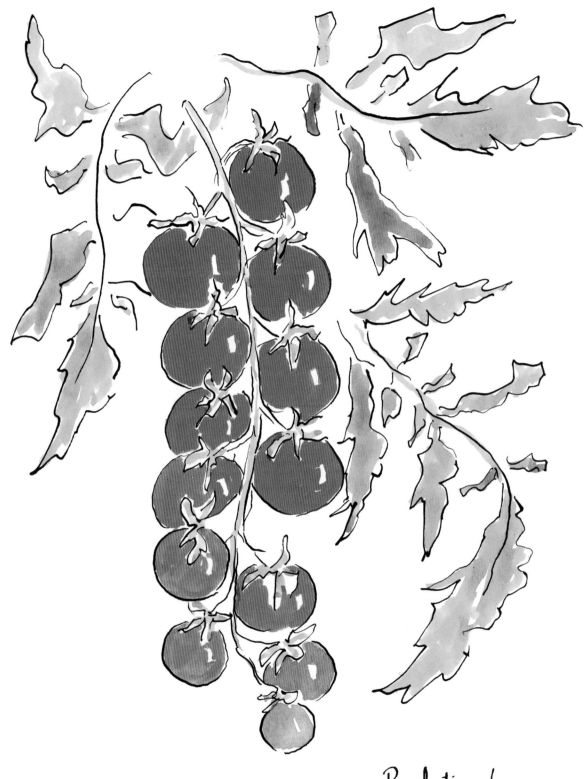

Perfection !

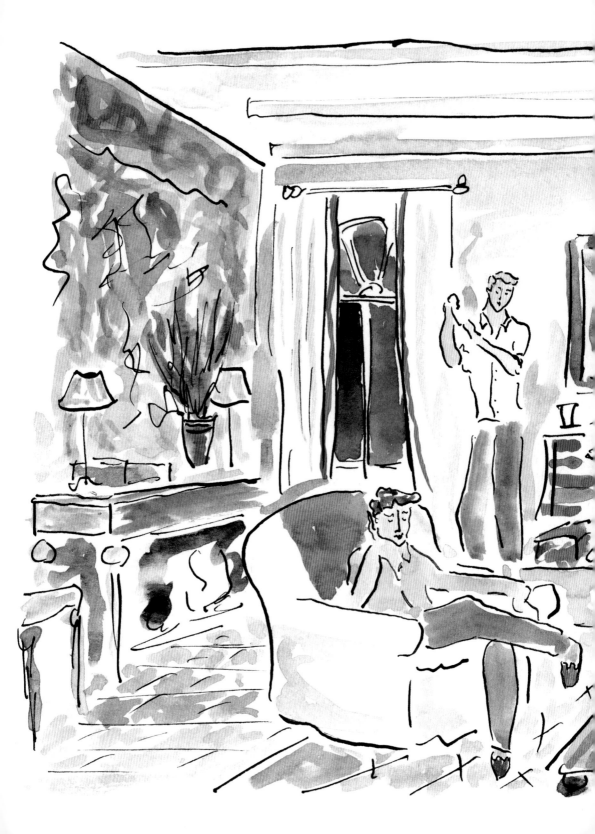

He makes a cracking Martini

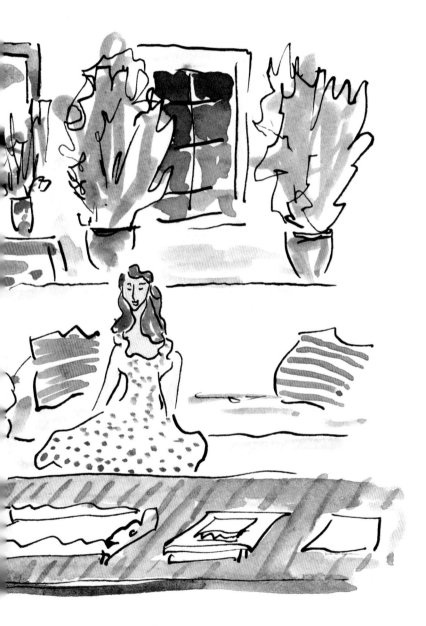

Friday

Nothing sour about this trip!

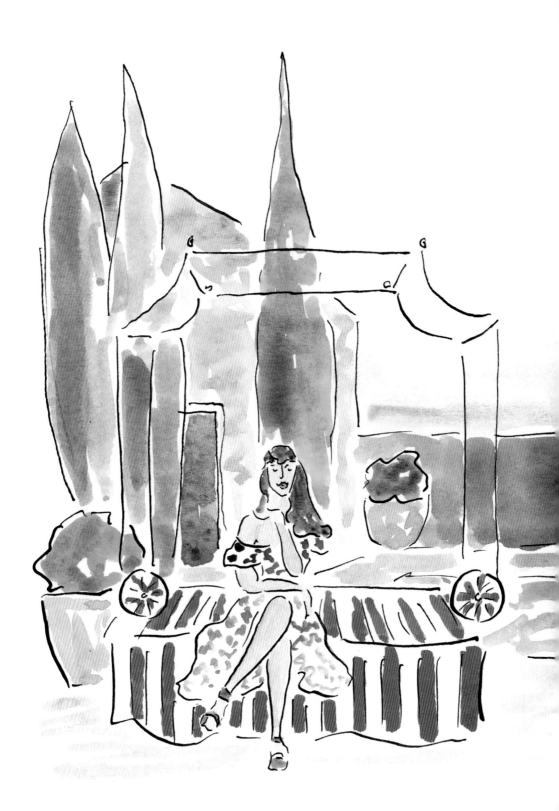

'The Hostess with the Mostess'

What's cooking?

Finocchio

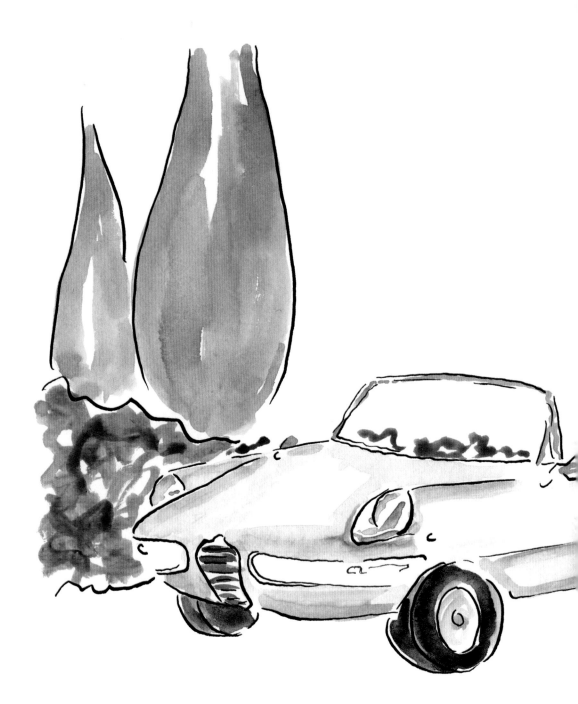

Time to move on

Via del Porrione, Siena

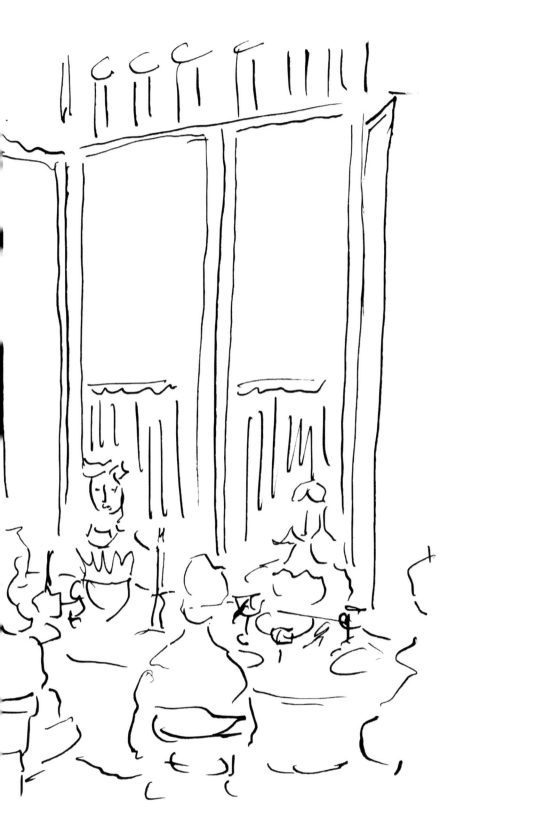

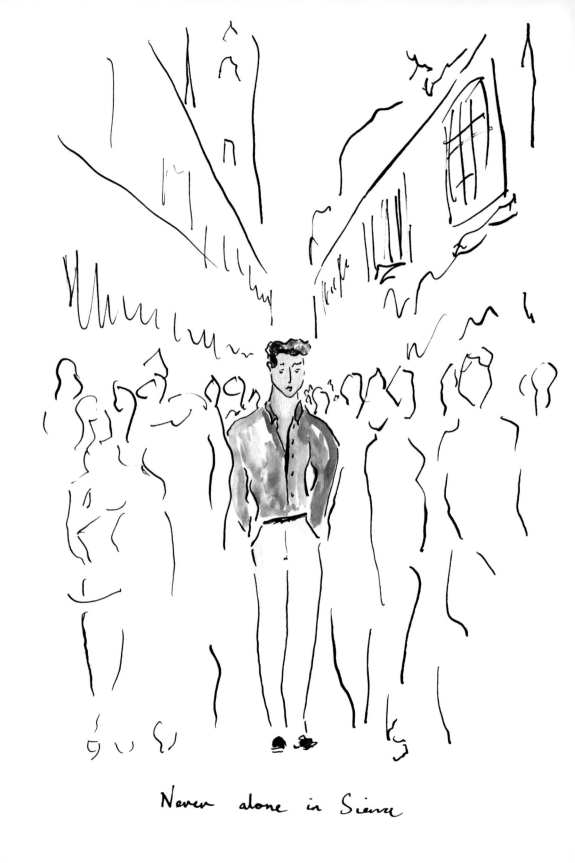

Never alone in Siena

35 ml Tanqueray
25 ml Campari
25 ml Martini Rosso
Blend with a twist

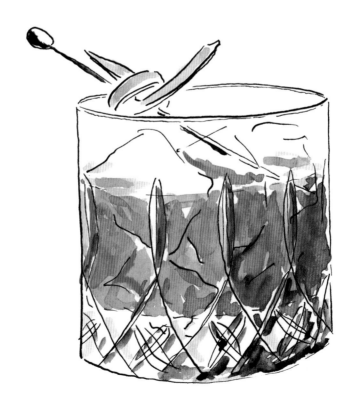

Saturday

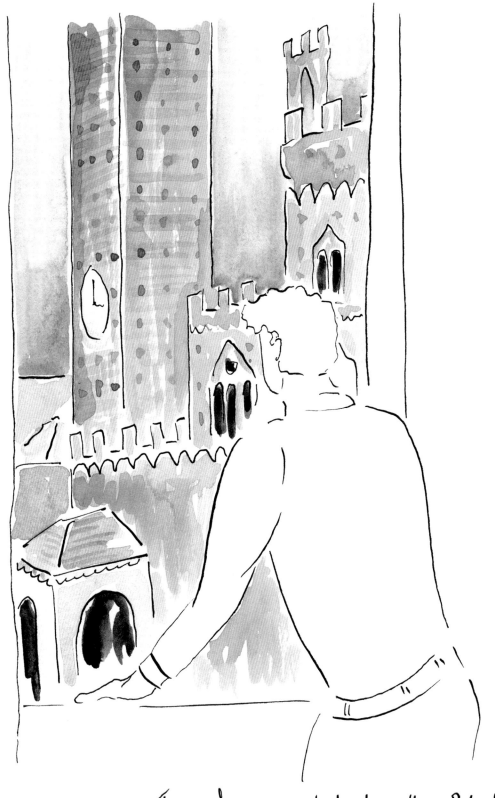

I must come back for the Palio!

When in Italy...

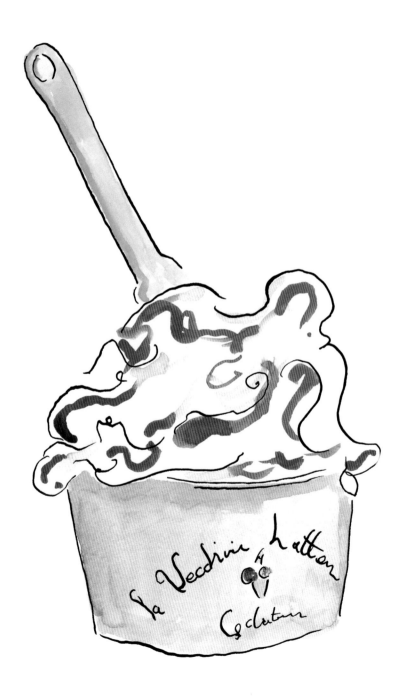

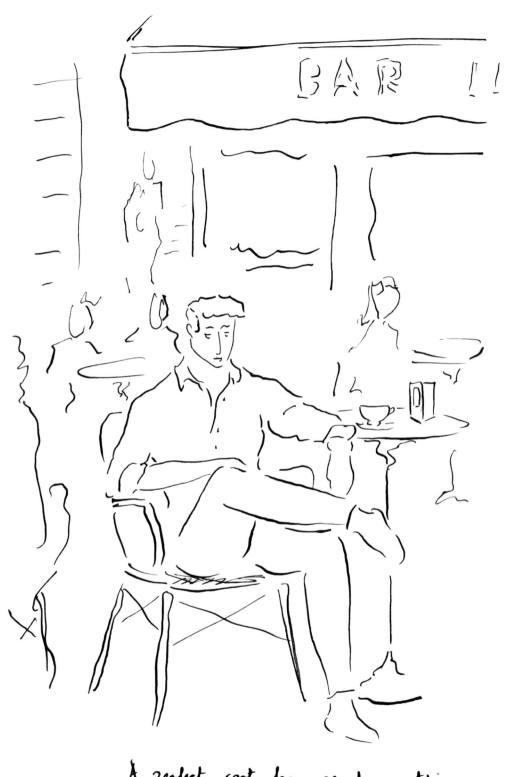

A perfect spot for people watching

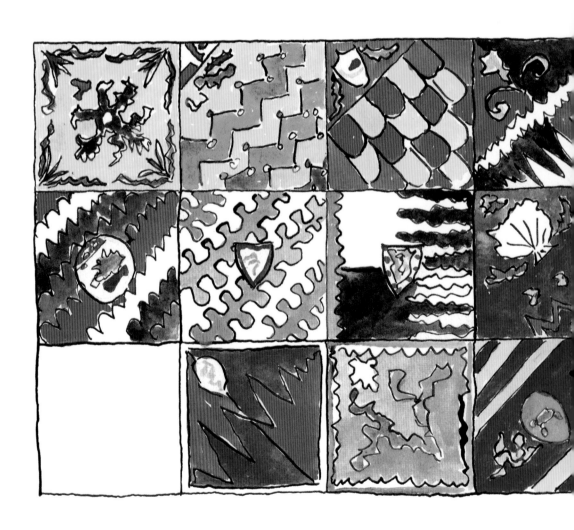

The Contrade of Siena

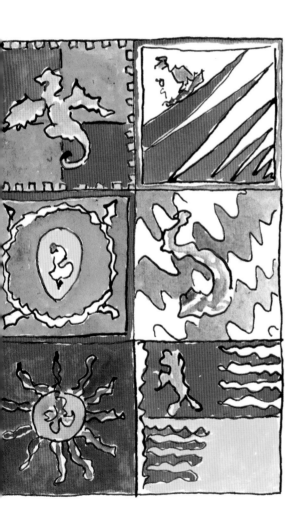

Towards the Duomo

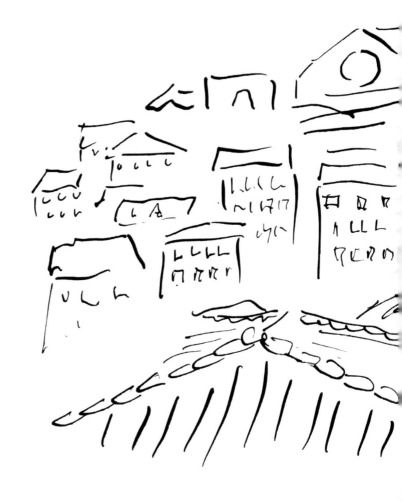

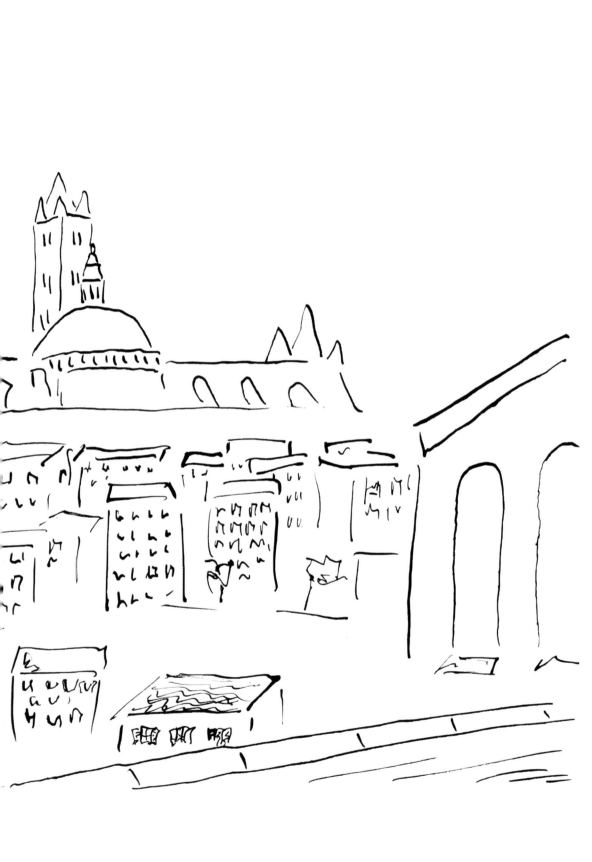

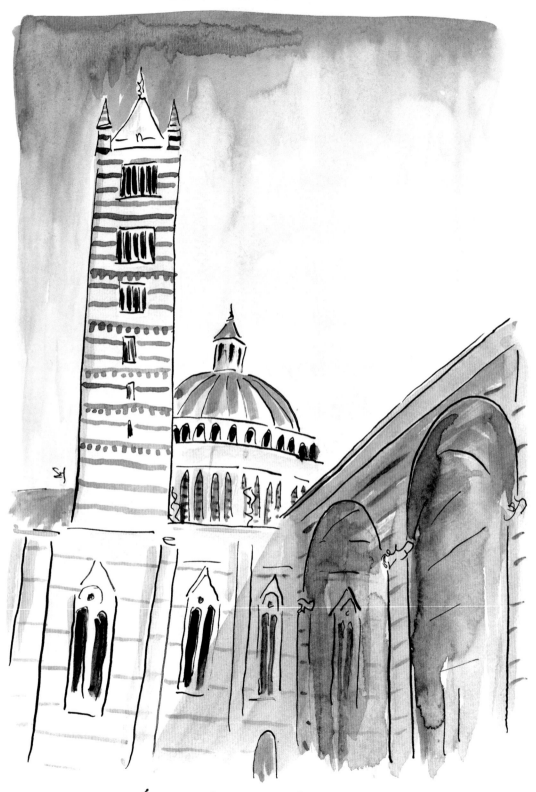

The colours of Siena

Villa Cetinale - hard to think of a better place
for a party

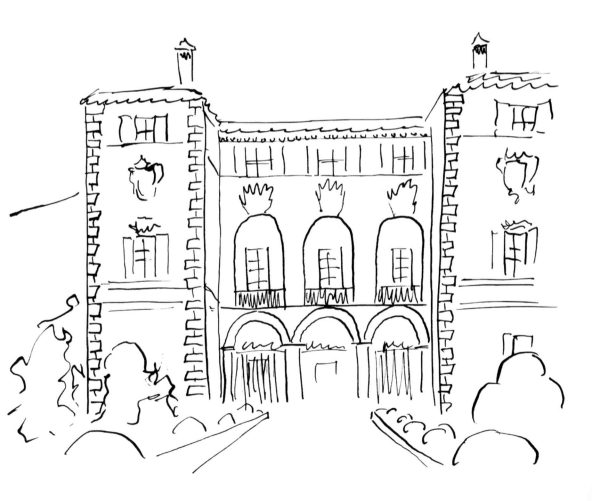

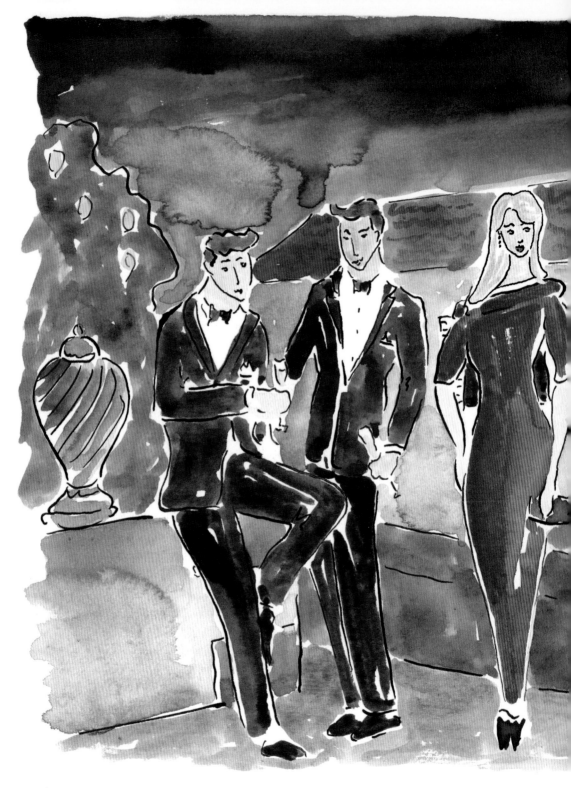

The promise of good things to come

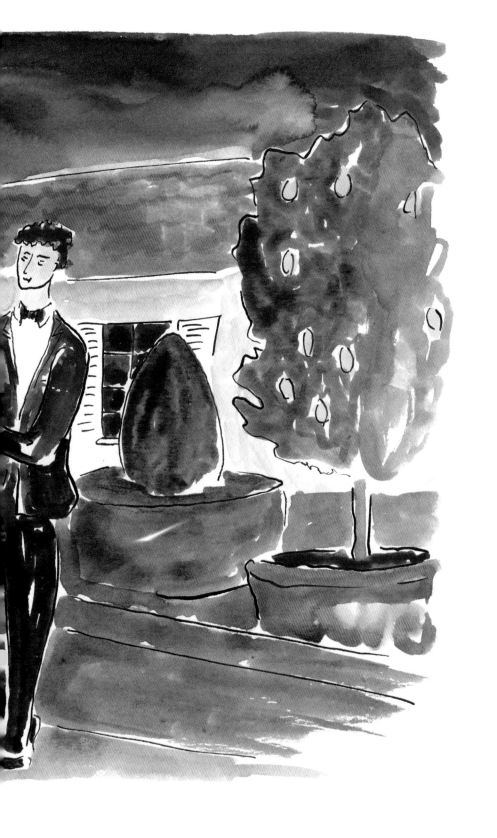

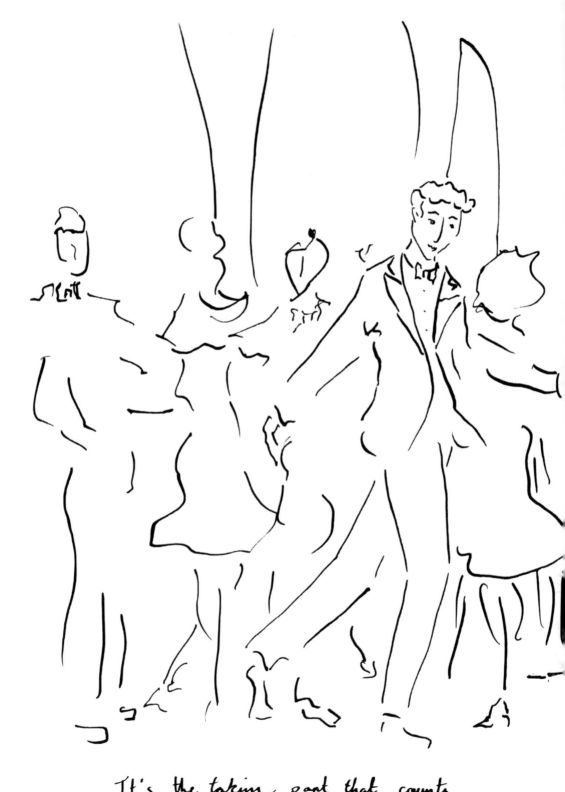

It's the taking part that counts

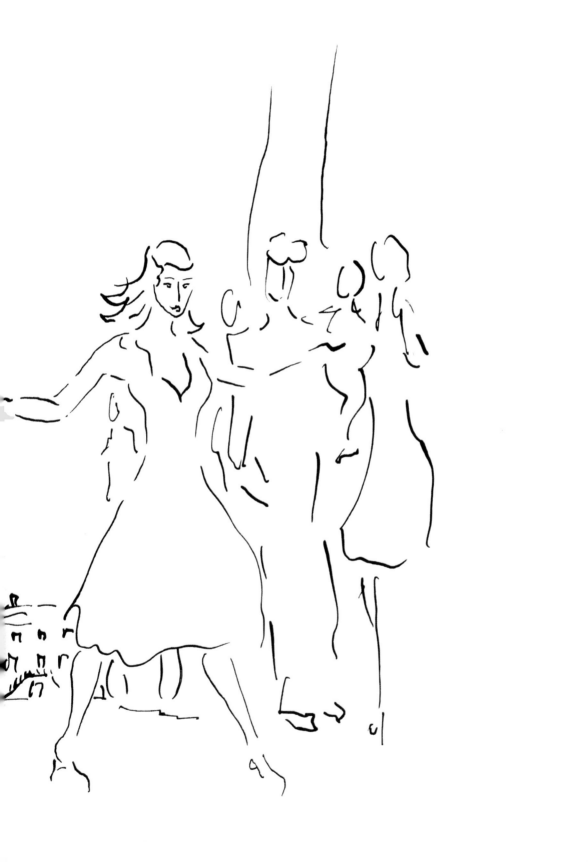

Sunday

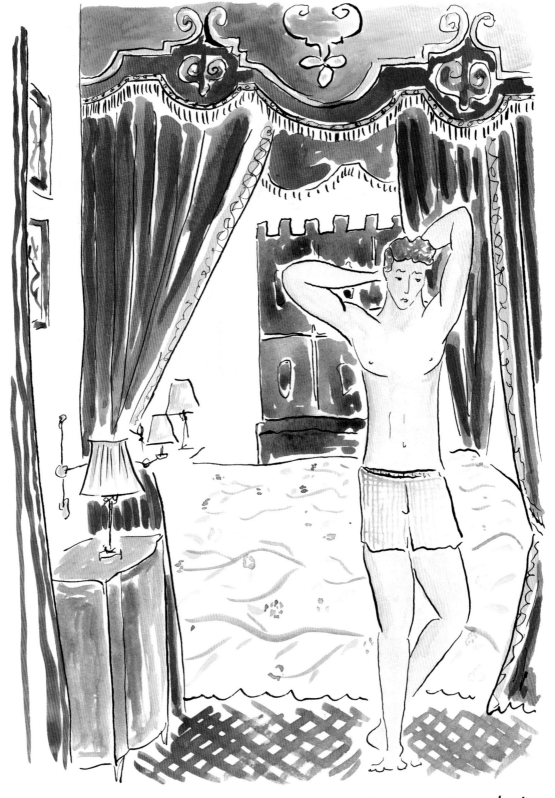

A very slow start

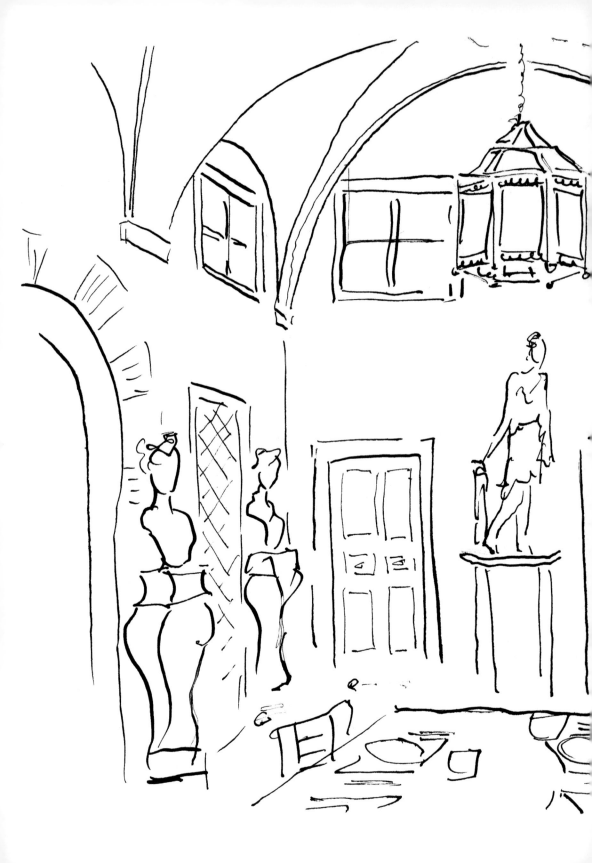

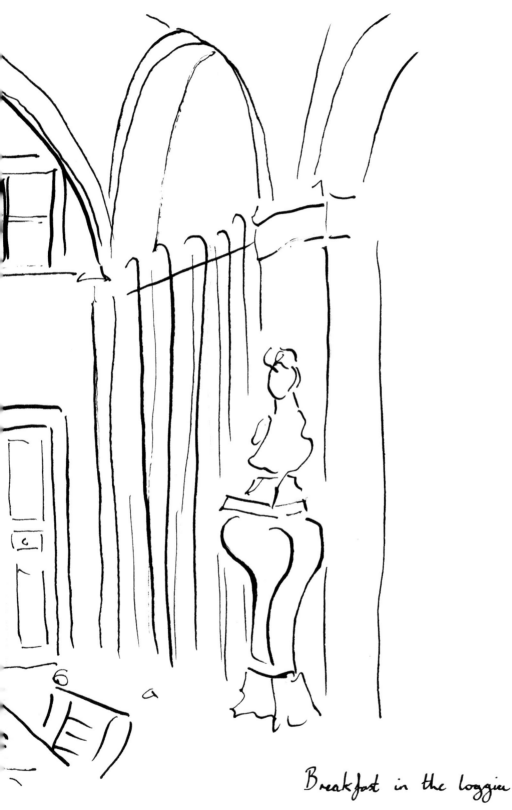

Breakfast in the loggia

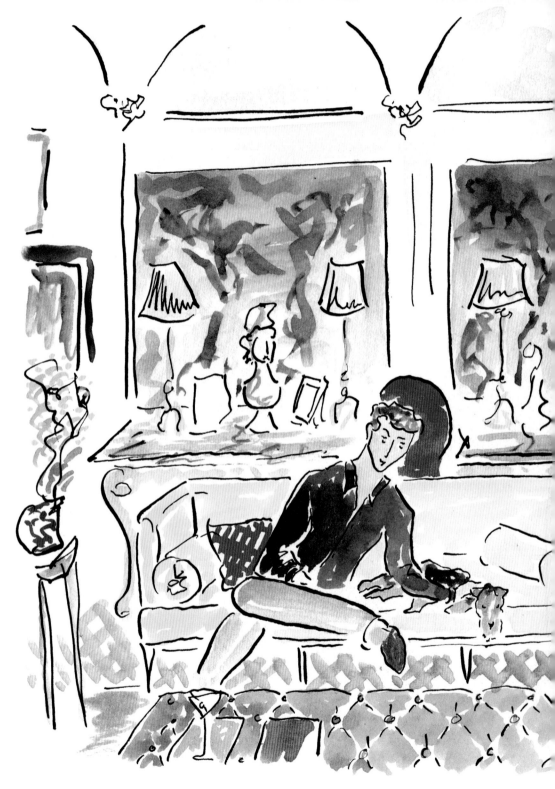

No dogs on the sofa (except this one)

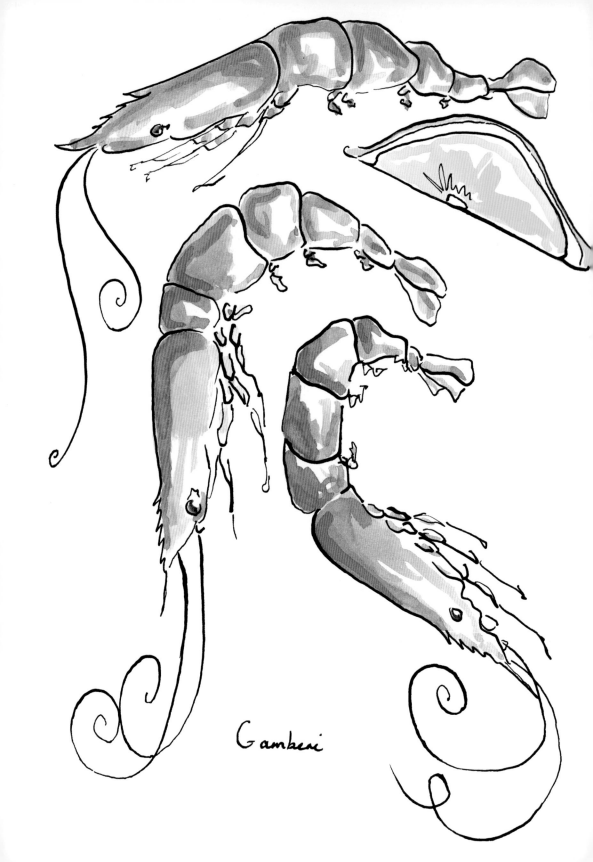

Gamberi

A few loops

Much refreshed!

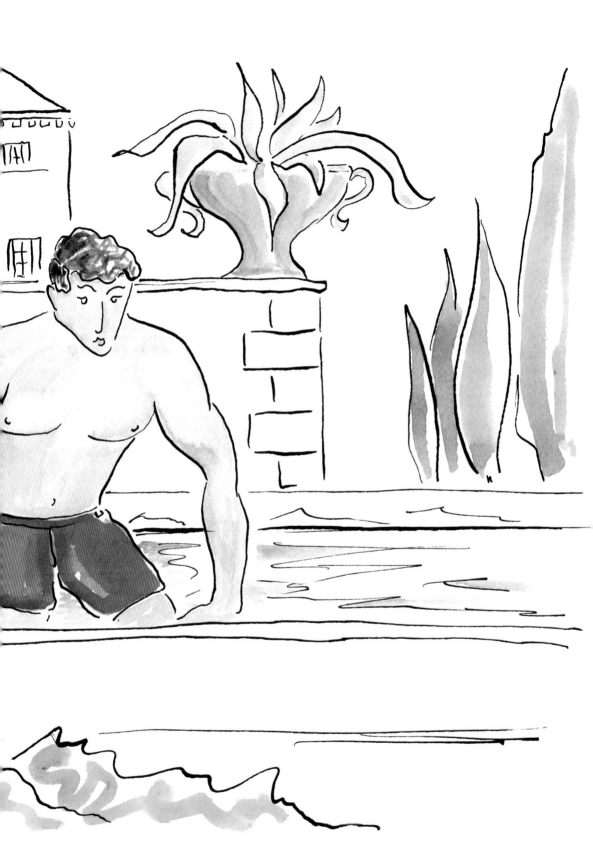

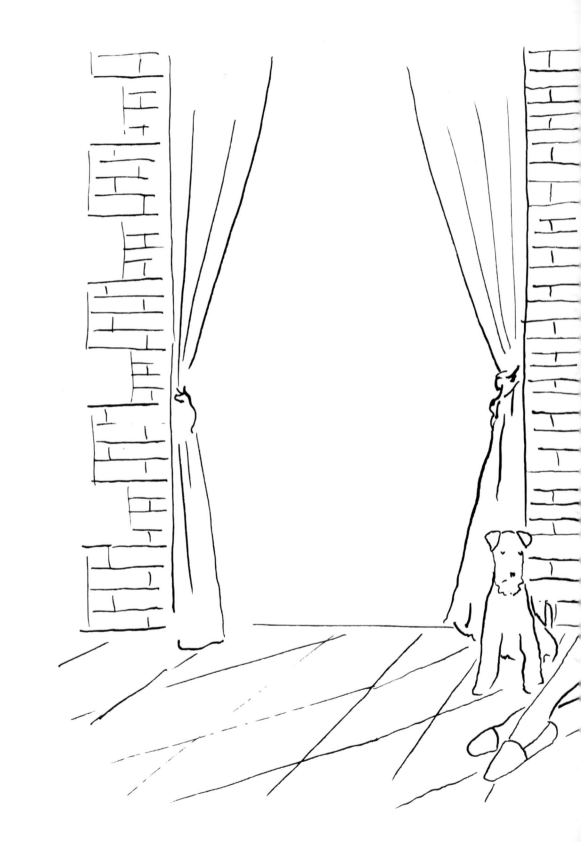

THE SKETCHBOOK
OF A GENTLEMAN
TUSCANY · ROBIN LUCAS

Published by New Heroes & Pioneers
Illustrations and text: Robin Lucas
Creative Direction: Francois Le Bled
Book Design: Daniel Zachrisson
Copy Editing: Matt Porter

Printed and bound by Balto print (Lithuania)
Legal deposit November 2018
ISBN 978-91-87815-27-0

"I would like to thank Amber Guinness and Matthew Bell, also
Emily Fitzroy all without whom this book wouldn't have been possible.
A very warm thanks also to all those in Tuscany who welcomed me,
over the years, to their homes, gardens, and businesses. I would also
like to thank my family and partner for their unwavering support."
– Robin Lucas

COLLECTIVE SHORTS
by NHP PUBLISHING